GODDESSES

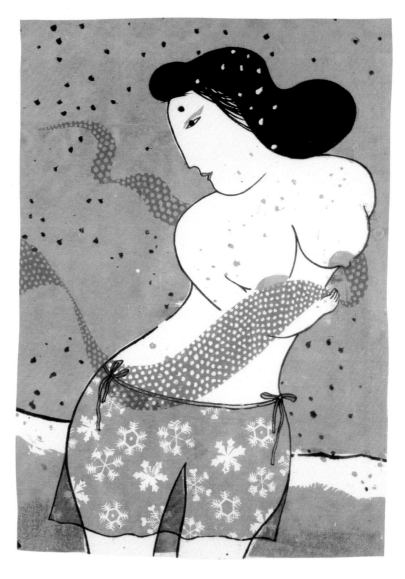

GODDESSES

Mayumi Oda

Lancaster-Miller Publishers

GODDESSES
by Mayumi Oda

Copyright © 1981 by Lancaster-Miller Publishers

LANCASTER - MILLER PUBLISHERS
3165 Adeline Street
Berkeley, California 94703
(415) 845-3782
Cable: LANMILL

Typography by the Tayloe Typesetting Co.
Printing by the Dai Nippon Printing Co., Ltd.
Design by Frances Butler.

Goddess in Snow (Title Page)
(22'' x 29'') 1973 ed. 35

Rainbow (Jacket)
(23'' x 31'') 1976 ed. 75

Library of Congress Cataloging in Publication Data

Oda, Mayumi, 1941-
 Goddesses.

 1. Oda, Mayumi 1941- 2. Goddesses-Art.
I. Title.
ND2073.03A4 1981 759.952 80-82396
ISBN 0-89581-010-7 AACR2

I can see myself when I was five years old, sitting on the tatami floor of our dining room. On the round, low table is a new set of crayons my mother has just bought for me, a precious gift in those difficult days just after the War. The sliding paper doors to the garden stand open; the crayons are bathed in light. The colors, spreading before me like an intense rainbow, beckon me. I begin to draw a Princess: golden-yellow hair, a pink bow, tiny red shoes. I surround the Princess with red and orange flowers and fill her sky with purple butterflies

I have never stopped drawing; and color continues to cast a spell on me. I love crayons, colored pencils, watercolors, and I love blank white paper, a space where I can make my dreams come true.

When I recall my past, it reveals itself to me in two different forms: as an infinite number of distinct moments like seeds, and as a vast emptiness. Sometimes I can take these tiny seeds in hand and examine them separately; other times they merge indistinguishably into an endless flow, a river of memories which empties into an even vaster sea.

I was born on June 2, 1941—the year of Pearl Harbor—in a suburb of Tokyo called Kyodo. My father, Yasumasa, twenty nine, had just completed his graduate studies in Buddhist history and was teaching History at the Imperial Army Academy. My mother was twenty-six, the youngest of seven daughters in a cultured and artistic family from "downtown" Tokyo. She married my father one year previously—an "arranged marriage"—and went to live with him and his parents in their Kyodo house. My mother was a tall, ample woman with unusually fair skin; she was often likened to the Kwannon Goddess.

The house where I was born and grew up is a typical middle-class Tokyo house in traditional Japanese style. My grandfather had purchased it with his retirement allowance; at the time, it stood alongside an identical house in the middle of a wheat field. That field has long since disappeared, but the house itself is unchanged. When I visit my brother and his family, who live in the house today, I become five years old again. Playing shadow games with my two nieces, I cast my shadow on the same white paper in the same sliding doors, smell the same earth in the garden where we sit playing on the same straw mat, watch the same afternoon light filter through the trees— nothing is changed, as if time has stopped.

The land on which our house stood belonged to the Matsubaras, a farm family who lived across the way. As I grew up, the seasons of the year were marked for me by the sights and sounds which reached us from the garden in front of their thatch-roofed farmhouse. In Spring, from the second floor of our house, the neighborhood children would stand watch, waiting for larks to start from their hidden nests in the garden and soar into the sky.

8

Summers, at the time of the Tanabata Star Festival, Mrs. Matsubara would cut a length of young bamboo for us to hang with origami animals and lacy paper cutouts. In August, for the Buddhist Festival of the Dead, *o-bon*, we fashioned "horses" and "cows" out of twisted cucumber and eggplant, with chopsticks for legs. We filled small paper "saddle-bags" with gifts of cut vegetables and fruit, attached them to the cucumber and eggplant beasts of burden, and stood the little animals around the bonfire lit by the adults to guide the dead back to their domain. Then we leaped back and forth across the fire, a game supposed to bring us health and long life.

Autumn arrived with its own special sights and sounds: the swish and crackle of wheat being threshed by hand; the sudden appearance of orange persimmons clustered heavily on the giant persimmon tree in the Matsubara's yard; the straw lean-to Mr. Matsubara erected around the base of the tree to provide a sheltered, sunny place to work. Autumn was the pickling season: large, white radishes called *daikon* were strung together with straw and hung outside the lean-to to dry in the sun. As the white radishes began to yellow, and give off their special pickle smell, Mrs. Matsubara, sitting just inside the lean-to, would begin paring persimmons to preserve. All the children in the neighborhood loved to sit in the sun and watch her; often she handed us the long persimmon parings to eat. Before we ate the parings, we liked to dangle them to the ground and compare their length with our own height. So skillful was Mrs. Matsubara that a single paring was often longer than we

were tall. When she tired of working, she would amuse us by making a tiny sword and scabbard out of a piece of straw. Plucking a loose thread from my red sweater, she would place it on my wrist like a trickle of blood, then "wound me" with the straw sword.

In December, the neighbors gathered in the Matsubara's yard to pound steamed rice into the "mochi" cakes we ate at New Year's. At a time in our lives when we were often hungry, the fluffy rice cakes spread out on the earth floor, gleaming whitely in the dimness of the room were a deeply reassuring sight.

Today, five houses stand on the site of the Matsubara's farmhouse. The bamboo grove, the persimmon tree, and the small Fox shrine with its red banner, rusty bell and porcelain figurine have all disappeared into the vastness of the past.

My name, MAYUMI, is Buddhist; it means "sandalwood," a hard, fragrant wood used to make Buddhist rosary beads and incense. My grandfather chose a Buddhist name for me in memory of his wife Ai, a devout Nichiren Buddhist and a passionate Socialist. Long before I was born, Ai had taken her own life, possibly because she was ill with incurable tuberculosis and possibly because of her despair with the political oppression of the times. Although the family never spoke about her death, it was clear to me even as a child that everyone had admired her as a woman of great compassion.

Ai died on the nineteenth of May; on the nineteenth of every month, a blind Buddhist

monk who had been her close friend came to our house to lead a memorial service. Often he was accompanied by his daughter. Before he arrived, my step-grandmother would prepare by cutting fresh flowers from the garden and placing them on the altar, lighting new white candles, and burning incense.

When the monk and his daughter arrived, the whole family would gather in the dim altar room and recite a Buddhist Sutra, usually the Lotus Sutra. I would sit on my father's lap and try to follow the difficult text. For the most part, it was incomprehensible to me. But one passage I did understand, perhaps because it appealed so directly to my child's imagination. I can recite it from memory to this day:

Tranquil is this Realm of Mind
Ever filled with Heavenly beings;
Parks and many places
with every kind of gem adorned,
Precious trees full of blossoms and fruits,
where all creatures take their pleasure;
All the Gods strike the Heavenly drums
and evermore make music,
Showering Mandarava-flowers
On the Buddha and his great assembly.
My pure land will never be destroyed.

Sometimes, in the middle of the interminable service, the monk's daughter would call me into the next room and show me how to fold origami cranes. She was wonderfully deft, her fingers slender and delicate. I liked to test her by insisting she make the cranes smaller and smaller. She would always oblige, beginning with one the size of a matchbox and working

her way down until finally she folded a crane no larger than a kernel of rice. Meanwhile, the chanting droned on in the next room: *NAM MYO HORENGE-KYO, NAM MYO HORENGE-KYO*

In those days we had a pond in our garden, shaped like a gourd. Every summer, the goldfish vendor would wheel his cart past our house, and my grandmother would buy each of us four children a goldfish. It was my job to feed them; squatting at the edge of the pond, I would summon the fish to the surface by clapping my hands, then throw them leftover rice. Toward the end of the War, when Tokyo was being bombed, my grandfather filled in the pond and built an air-raid shelter beneath it. Huddled in the shelter in the middle of the night, I would watch the winking lights on the B-29's as they flew overhead—the lights in the dark sky looked to me like the Devil's eyes and filled me with fear.

The "new Democracy" of the post war years was supposed to include equality for women; but it was clear to me that women were still being treated as second-rate citizens or worse. When I was in the sixth grade, our female teacher told the girls to remain after school one day. When the boys had left the room, she lectured us briefly about menstruation, her voice hushed and embarrassed. That gruesome "kit," and the diagram of the womb she drew hurriedly on the blackboard, made me feel that being a woman was somehow shameful and unclean.

The day I got my first period, my mother

prepared *o-seki-han*, rice steamed with red beans, an auspicious dish reserved for celebrations. The special rice was served to the family without a word of explanation, to keep the other children in the dark—it was an unspoken ritual for the adults, a silent "celebration" of my passage to womanhood.

In Junior High School, to my grandmother's dismay, I liked to play and especially to fight with the boys in the neighborhood, and was constantly being admonished to "behave like a girl!" I was known as "Miss Tarzan," because of my habit of climbing onto roofs and into trees. To spend time alone on a roof or high in a tree gave me an exhilarating sense of liberation. It was there, perched high above the neighborhood, that I began reading Colette and George Sand. I am not sure what precisely in those writers attracted me so; what I do know is that the image of women I found in Japanese literature—somehow unclean and ashamed—was repellant to me.

I went to a girls' high school. Dreams of marriage filled the heads of most of my classmates. They looked forward eagerly after graduation to preparing themselves for marriage by studying tea ceremony, flower arranging and cooking. Their unquestioning acceptance of this "happiest of possible futures" for a young woman in Japan made me angry: I could not like them.

I did have one good friend, Kazuko. Her elder brother was the ideological leader of the Leftist Student Movement and was translating the Collected Works of Trotsky. He would often shuffle into Kazuko's room when we were there doing our homework, a wrinkled old cap pulled down over his head and his eyes hidden behind the dark glasses he always wore, to give her books he wanted her to read. It was at this time that I too began reading Sartre and de Beauvoir. Often, Kazuko and I ditched school and went to see films by Cocteau and the New Wave directors appearing in Japan at that time, Truffaut and Godard. Kazuko and I considered ourselves very much a part of the avant-garde. She turned to politics; I began to prepare in earnest to enter the National Academy of Art.

The entrance examination was notoriously difficult. In those days, one out of thirty applying students was accepted. To have even a hope of passing, one had to be able to draw whatever one saw or could imagine: hard things, soft things, shiny, transparent, fluffy things—anything and everything. At home, I worked hard for two years, drawing everything in sight: a lacy cloth covering a child's tricycle, flowers in a vase and a piece of fish, a honey jar alongside a piece of crinkled tin-foil, an apple reflected in the foil. On my third try, I passed the entrance exams and was admitted to the Academy in the department of Arts and Crafts. But the Academy's academic approach to art was stifling to me; I felt disappointed, and trapped.

While I was still in my Freshman Year I met John Nathan, a young American who had just graduated from Harvard and was in Japan studying Japanese Literature. John spoke fluent Japanese; we spent hours in coffee shops all over Tokyo, talking and talking. When I told my parents that I wanted to marry him, they consented, but made me promise to re-

main in Japan until I had finished school.

We were married in October, 1962, and lived in Japan until the spring of 1966. John had a Honda motorcycle. We bought helmets, a red one for me, a white one for him; and we rode to school together. We listened to modern jazz, Thelonious Monk, Miles Davis, John Coltrane, and at night John read me James Joyce and Faulkner. Sometimes he would play his recorder and I would sing Joan Baez and Bob Dylan songs. I was living like an American. And I felt free, free of my family, my school, and especially free of my Japanese womanhood. I felt that John held the key to my liberation.

In 1966, when I graduated from the Academy, we moved to New York. Since then I have lived in the United States and have experienced much of what American women my age have gone through in these difficult and interesting years. In 1967, in New York, I gave birth to my first son, Zachary Taro. My second son, Jeremiah Jiro, was born in Cambridge, Massachusetts, in 1970. My studio in Cambridge was in the dark basement of our Victorian house. Whenever I could steal time from housework and caring for two small boys I would rush downstairs to work. It was in that dim basement beneath the deep Boston snow that I began silk-screen prints of women in exorbitant color. Working there in the basement, I felt that I had reclaimed myself.

The Women's Liberation Movement was just beginning in those days, and everyone was full of excitement and energy. Women felt victimized by men and Society, and they were angry. I was angry, too. But the experience of giving birth and raising children and being an artist at the same time made me realize my own strength and the potential power of all women. Deep inside me a voice was saying: "We are strong, we must only realize our own strength."

Nonetheless, I continued to follow John wherever he went. When he took a teaching job at Princeton, we moved there. We lived in an 18th Century farmhouse in the middle of a soybean field, and my studio was in the attic. From the attic window I could watch the seasons change much as I had done when I was a child. In the spring, as the heavy snow melted, wild daffodils burst from the wet ground and crab apples, double-petaled cherry trees, magnolia and pink and white dogwood drenched the town in color. Every summer we had a vegetable garden: tomatoes, corn, green pepper, lettuce and beets all summer long. In the autumn the maple trees turned yellow and a combine came to harvest the soybeans in the field.

I was working hard, my sons were growing up, and life in general seemed peaceful enough. But I could sense that John and I were growing apart—something was lacking. All my life I had been seeking liberation, but from what? I felt I didn't know. I began reading in Japanese again, and discovered two women writers, Raicho Hiratsuka and Kanoko Okamoto, who became very important to me. Both were Buddhists, and both had discovered through their Buddhist practice a source of vital power within themselves which they identified as a long-forgotten female vitality and strength—the creative power of primeval Woman. Raicho

Hiratsuka wrote in 1911 for the introduction of a new feminist magazine called *SEITO*, which means Blue Stockings, from the English feminist movement.

> In primeval times, women were one with the sun and truth of all-being.
>
> Now we are like pale faced moons who depend on others and reflect their light.
>
> Women, please let your own sun, your concentrated energy, your own submerged authentic vital power shine out from you.
>
> We are no longer the moon.
> Today we are truly the sun.
> We will build shining golden cathedrals at the top of crystal mountains, East of the land of the rising sun.
>
> Woman, when you paint your own portrait, do not forget to put the golden dome at the top of your head.

As I read their novels and essays, written before the war, I began to feel in touch with my own power as a woman. It was as if a sun inside me had finally broken through the clouds. Goddesses became my theme, and silk-screen prints of Goddesses seemed to create themselves.

In 1978 we spent a year in Tokyo and I began to practice *zazen*, Zen meditation. I felt compelled to know myself more deeply. When we returned to the United States I decided to continue my Zen practice and moved to Muir Beach, next door to the Zen community at Green Gulch Farm. John moved with me, but not long after, we separated.

Living my own way for the first time, my life begins at last to make sense to me. To work and meditate and paint on the Zen farm comes naturally to me; it takes me back to the life I led as a child. I am often totally alone, but never lonely.

One day not long ago, I had a dream. I am sitting quietly in the middle of a vast field which leads to the beach.

John is sitting at my right hand, my two children at my left. Standing around and behind us, as in a family photo, is everyone in my life who has been important to me: my mother and father, my grandparents, my real grandmother Ai, my art teachers, Richard Baker Roshi, friends from Green Gulch farm, from New York, Cambridge, Princeton, and Tokyo, even our old horse Patches is there, and our dead dog, Jessie. White clouds are floating in the sky; surf breaks against the beach. A fountain of tears is streaming from my eyes. But I am smiling.

Mayumi Oda
Muir Beach

GODDESSES

This book is for my two grandmothers
 Ai Oda
 Hisayo Oda
and my mother
 Aya Oda

Manjusuri

Manjusuri is the perfect wisdom Bodhisattva,
usually depicted with a sword. This feminine
manjusuri carries a sutra as a symbol of clarity.
(29" x 40") 1980 ed. 50

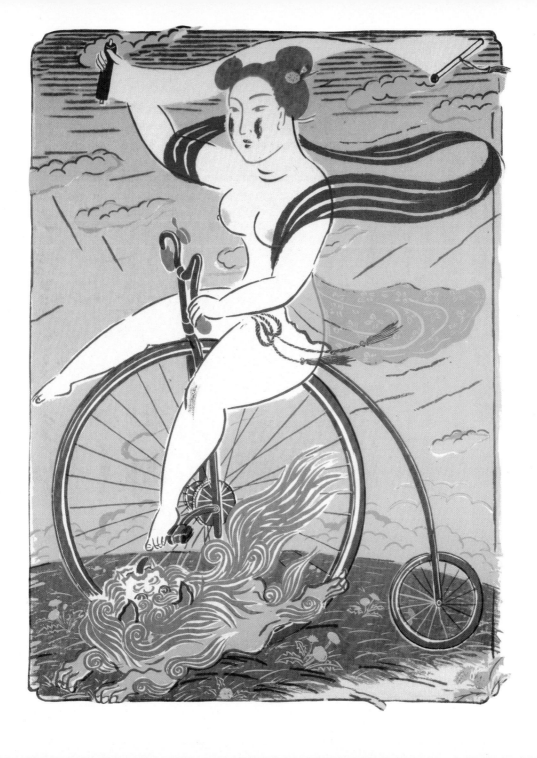

Thunder Goddess

The THUNDER GOD was an evil demon in the sky. When angry, he would hurl lightning bolts, and then descend upon the house and eat the belly-buttons out of children. Whenever we saw lightning we would rush under the mosquito netting with my grandmother, terrified; and grandmother would repeat this Mantra with all her might: *Nam myo horenge-kyo.* *(22'' x 29'') 1970 ed. 50*

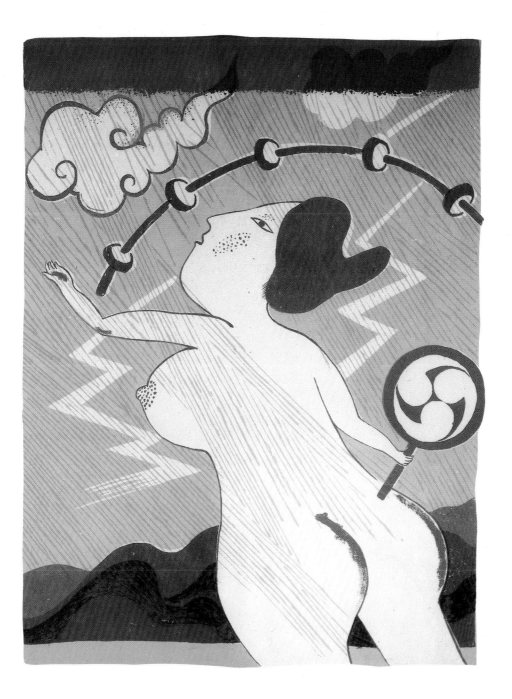

Sea Goddess

Kanoko Okamoto, the novelist, was born on the banks of the Tama River late in the 19th Century. In her novel *The Wheel of Life*, a woman named Choko (child of butterfly) abandoned her home and her lover and became a beggar drifting down the river, until finally she is swept into a vast sea called Life. For Kanoko Okamoto, both the river and the Sea represented the vast power of womanhood. She wrote:

> The river is bountiful, as though nour-
> ished by an inexhaustible breast;
> The River empties into a vast Sea enfold-
> ing everything, never ending.

(22" x 29") 1973 ed. 35

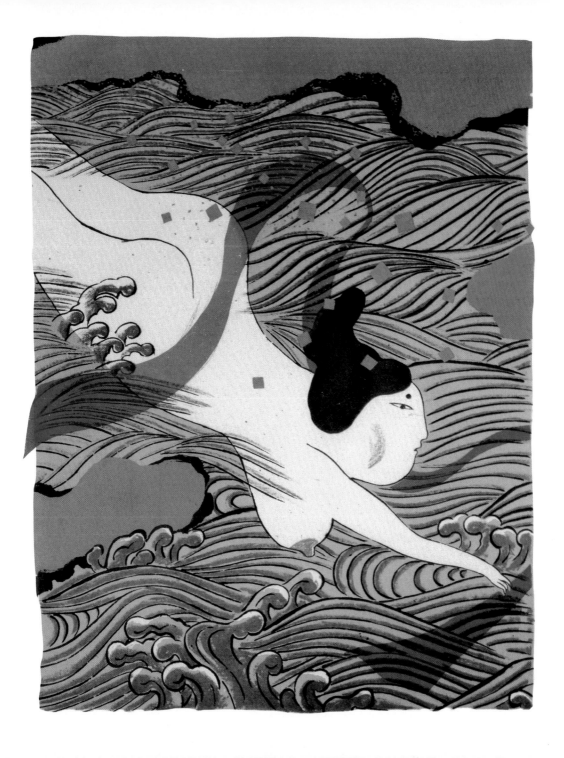

Deep Sea

My grandfather often told the children old folk tales. There once was a fisherman named Urashima Taro. One day he saw the village boys harrassing a sea turtle and saved its life. To show its gratitude the turtle led Urashima Taro into the ocean depths to the Ryugu-jo (the palace of the sea dragon). There, Queen Otohime entertained him for many days and nights. He enjoyed himself so much that he forgot all about the time that had passed. When he realized that, he told her that he had to leave. Otohime gave him a beautiful box as a souvenir, but told him not to ever open it. When he returned to his village, everything had changed. He felt lonesome, and of course he opened the box. White smoke came out and turned him into an old man. I felt so sorry for Urashima Taro, but I was fascinated by Otohime and the Ryugu-jo Palace. My grandfather told us that they were too beautiful to describe. Listening to his low voice and staring at the wooden patterns of the ceiling, which very much resembled ocean waves, I tried to imagine that beauty. I often was swallowed into the vastness of the ocean.

(22'' x 29'') 1975 ed. 30

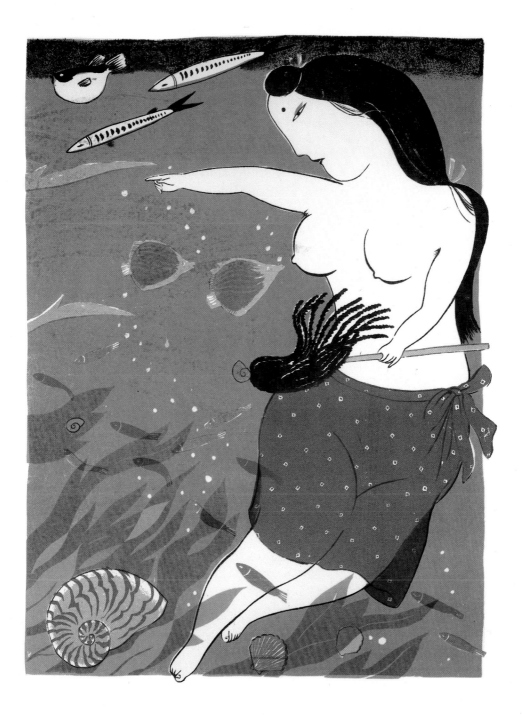

Wind Goddess

Earthquake, flood and typhoon winds were scary events in my childhood. The typhoon blew from the south, east of the China Sea. I do not know why, but usually each one was named a Western woman's name. Radio weather forecasters would anounce: "Typhoon Jane is heading toward Tokyo, with winds up to 60 km an hour and will arrive in Tokyo by midnight. Please shut your rain doors tight and stay home tonight."

(22'' x 29'') 1970 ed. 50

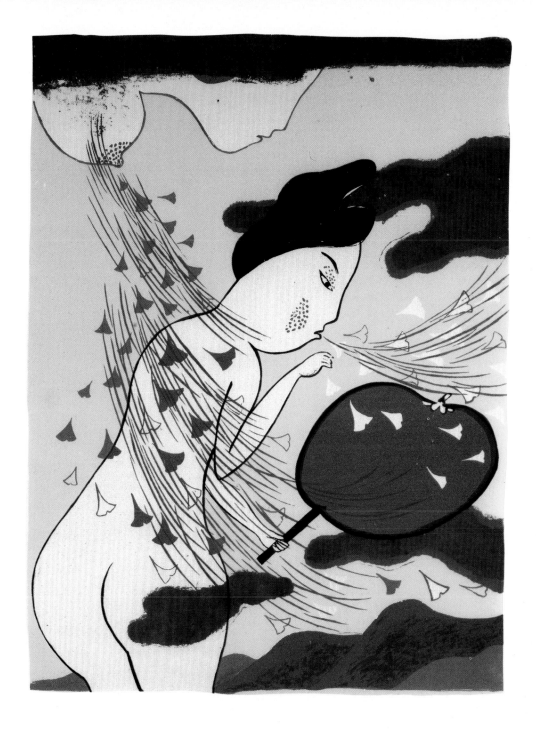

Goddess in Autumn

The old Japanese house I grew up in was made of wood and paper. In Autumn, typhoon winds would rattle the rain doors and whistle through the rooms.

(24'' x 29'') 1974 ed. 35

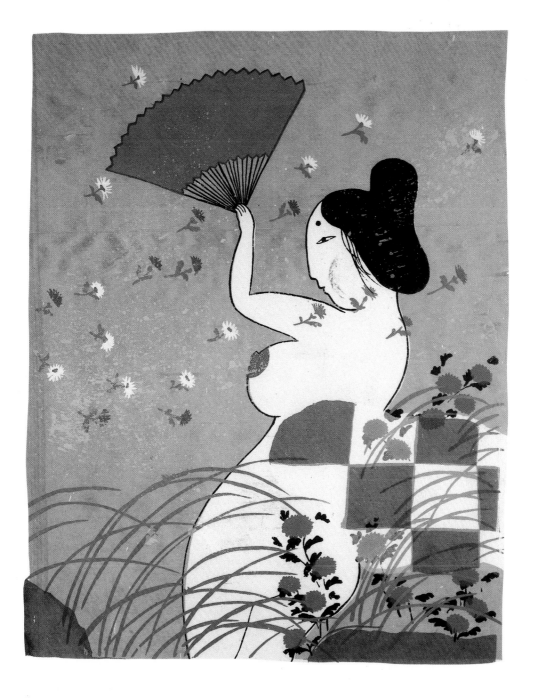

Goddess Hears People's Needs and Comes

Kannon (Avalokiteshvara Bodhisattva) means a person who *sees* the *sounds* of the world and perceives the cries of people in distress. She can manifest herself at will to help mortals. *(24'' x 33'') 1976 ed. 75*

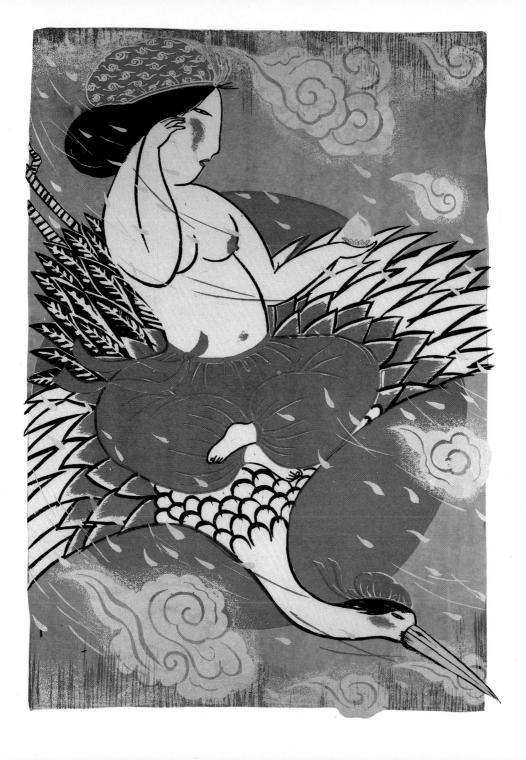

Treasure Ship, She Made
the Magic for Their Dream

A part of the traditional Japanese New Year was the appearance of the "dream vendor" on New Year's Morning. He would travel from town to town, selling simple woodblock prints of treasure ships loaded with Gods and Goddesses, sacks of rice, jewels and flowers. People would buy the prints and place them under their pillows, in hopes of having a good dream for the coming year.

(24" x 33") 1976 ed. 50

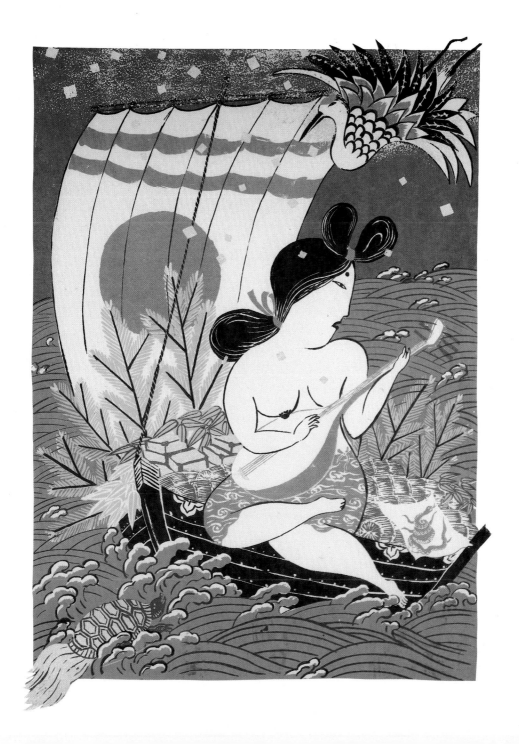

Treasure Ship on the River of Our Mind

Traditionally, there are seven happy deities aboard the Treasure Ship. Six of these are male, including the Gods of Wealth, Fortune, and Longevity. The sole female is Benten, Goddess of Art and Music. Benten is the Muse of the East.

(23'' x 32'') 1976 ed. 50

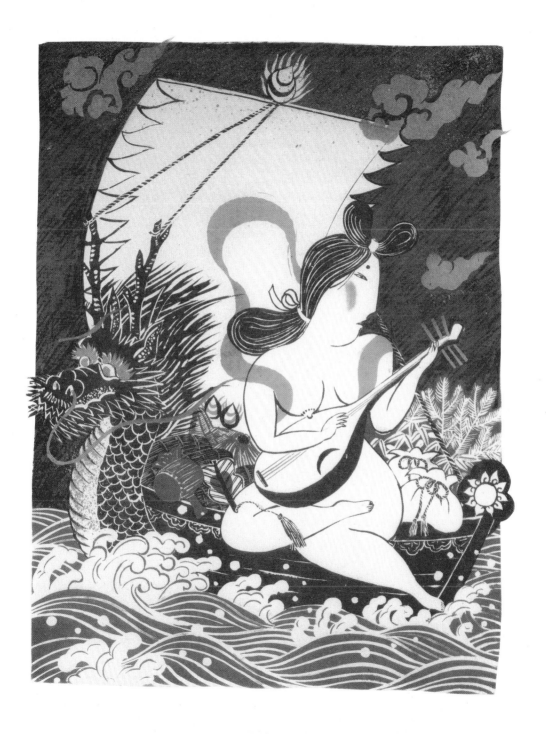

Treasure Ship, Goddess of Flowers

My grandmother was a wonderful seamstress. All the day long, sitting in a sunny corner of our family room, she sewed kimonos and quilted vests for her family. Toward the end of her life she was nearly blind, but she continued sewing until the day she died. When she finished something she would hold it up to me and say, squinting to see the cloth, "What a lovely design for you, Mayumi." We both loved flowered patterns, especially chrysanthemums, peonies, and wisteria.

(24" x 33") 1976 ed. 50

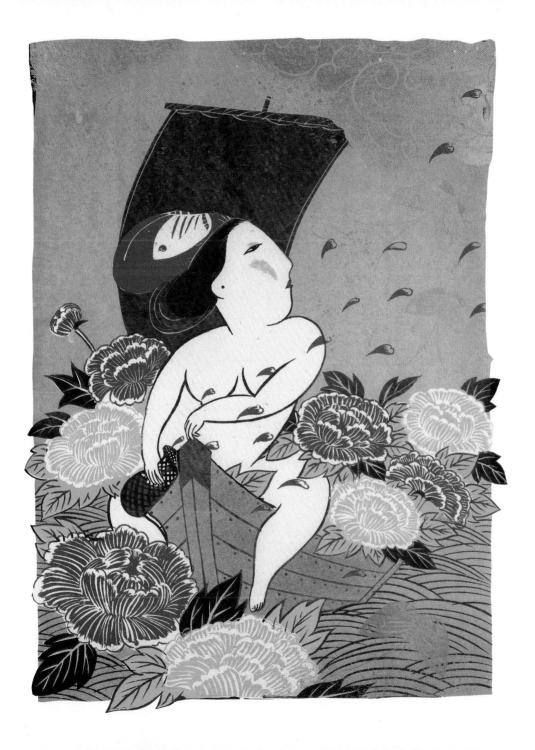

Treasure Ship, Goddess of Earth

When I see a plant or vegetable growing, I wonder where it comes from.

(23'' x 32'') 1976 ed. 50

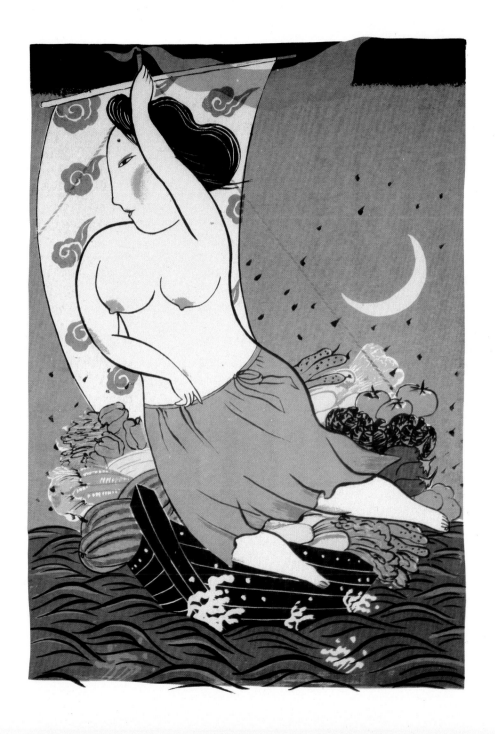

Treasure Ship, Spring Goddess

I wrote this for the announcement of my
exhibition for the treasure ship series in 1978.

Long night —
from the distance of deep sleep
I awake and see,
in my lucky direction,
the Benten Goddess —

These days I keep hearing a song I had to
practice on my shamisen when I was five and
six but could never understand. Especially
when I am in America, on my farm in Prince-
ton, early in the morning when the sun lifts
into the sky from the distance of the horizon,
the treasure ship in that song sails toward me
in a vision. When that treasure ship arrives I
dream of loading it with rice and vegetables,
wild flowers, beasts and the people I love and
then setting sail toward the light in my lucky
direction. I am at the helm.

(23'' x 32'') 1976 ed. 50

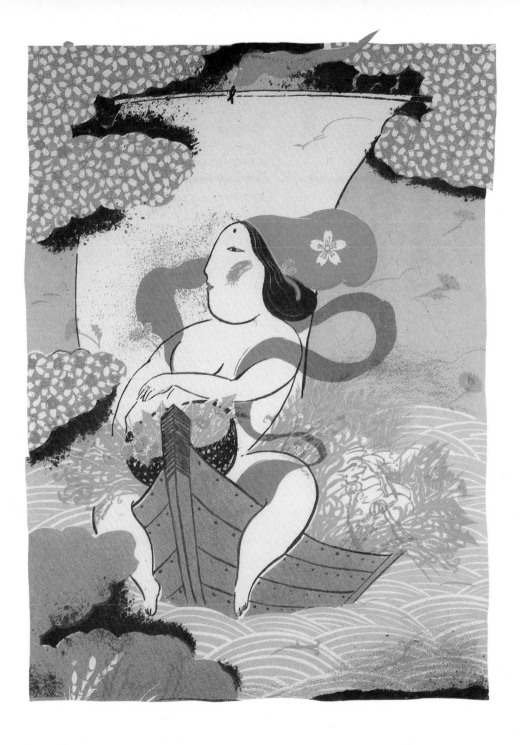

Treasure Ship, Goddess of Snow

Al Huang is a Tai-chi master and a wonderful self-taught flutist. His ancient bamboo flute came to him through many many people's hands. This flute had an amber color and was almost transparent. One day he played it for me and I painted him as the Goddess. I hope he doesn't mind.

(23'' x 30'') 1976 ed. 50

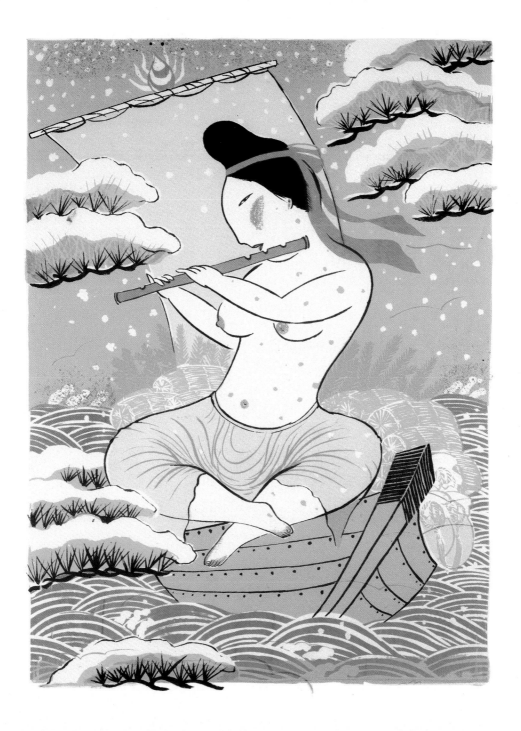

Thunder Goddess

There are famous paintings of the Thunder
God and the Wind God by the 17th Century
painter Sotatsu. These Gods are angry and
frightening. I simply transformed them into
Goddesses.

(26'' x 38'') 1977 ed. 50

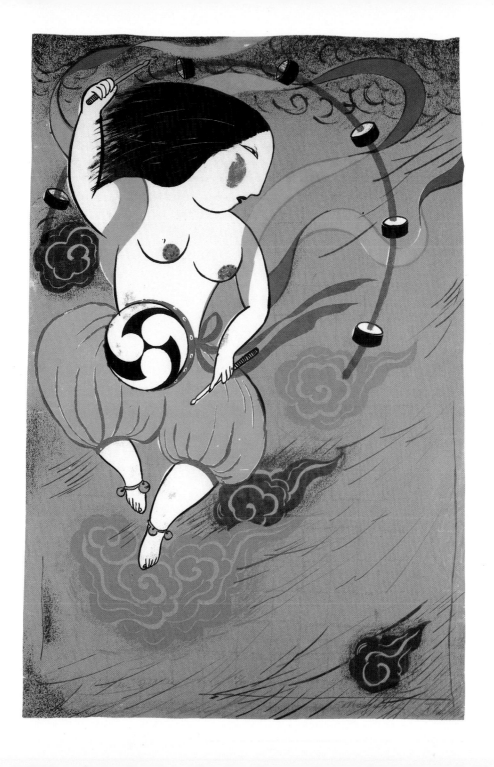

Wind Goddess

I do not think of myself as a feminist but I believe in the strength and vitality of the female. We are creators and our maternity comes out of a universal womb.

(26'' x 38'') 1977 ed. 50

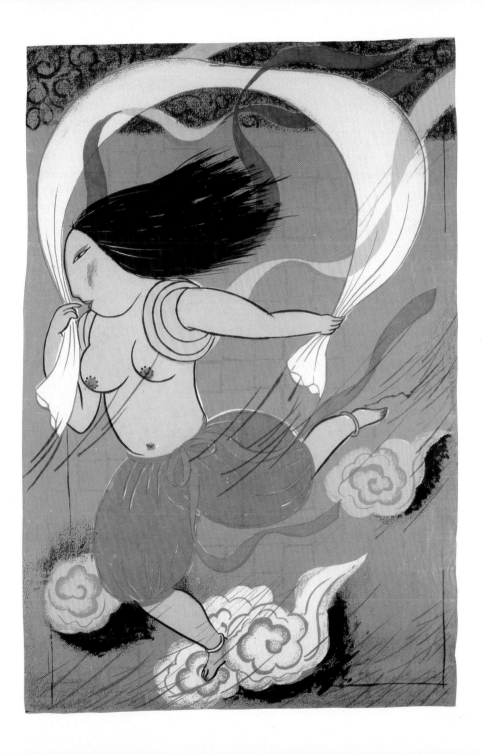

Sunset

In my early teens, my father took me to one of the big department stores to see the Ukiyo-e (traditional woodblock prints of the floating world). They made such a strong impression on me that I wanted to draw exactly like them. I love Harunobu, Hiroshige, Hokusai and Utamaro very much and now I feel that they paint with me.

(15'' x 21'') 1975 ed. 40

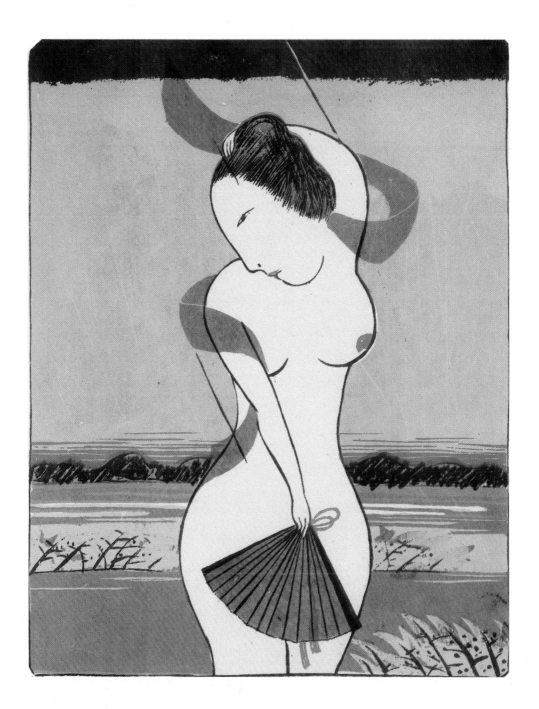

Green Mountain

Mt. Fuji is the sacred spirit itself for the Japanese. From the upstairs window of my parents' house, we could see it, especially in the clear early morning. Mt. Fuji gave me a feeling of tranquility, I understood why Hokusai painted 36 views of it.

(16'' x 20'') 1975 ed. 50

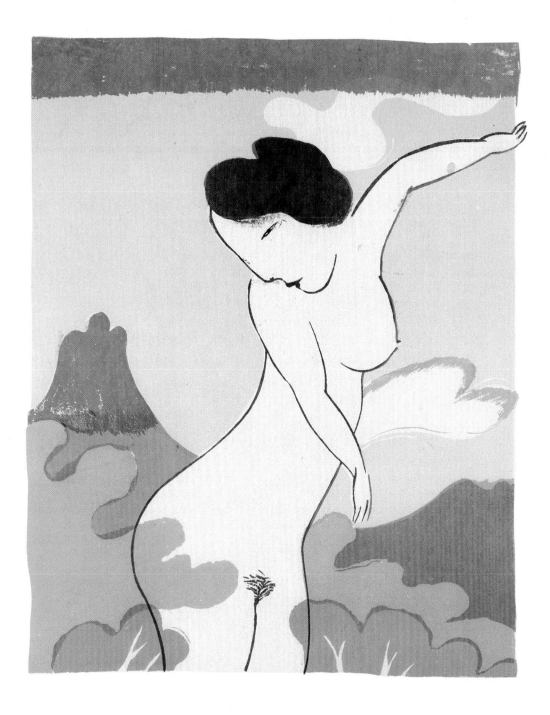

48

Victorian Invention. Bicycle

All through high school I felt confined, imprisoned inside my blue uniform, except when I rode my bicycle to and from school; a five mile journey through fields and paddies. Whenever I had time I would get off my bike in the middle of a cabbage field and take a deep breath—that was always a moment of liberation.

(16'' x 23'') 1977 ed. 50

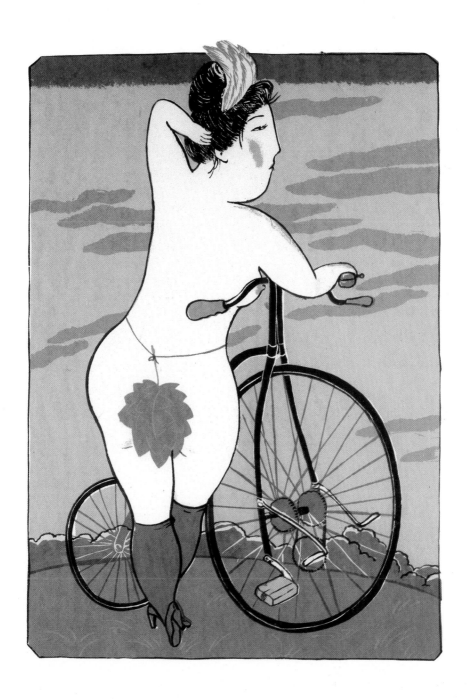

Victorian Invention. Bell Telephone

We owe our convenience and comfort to many 19th Century inventors. Without Alexander Graham Bell, many people could not exist today.

(16" x 22") 1977 ed. 50

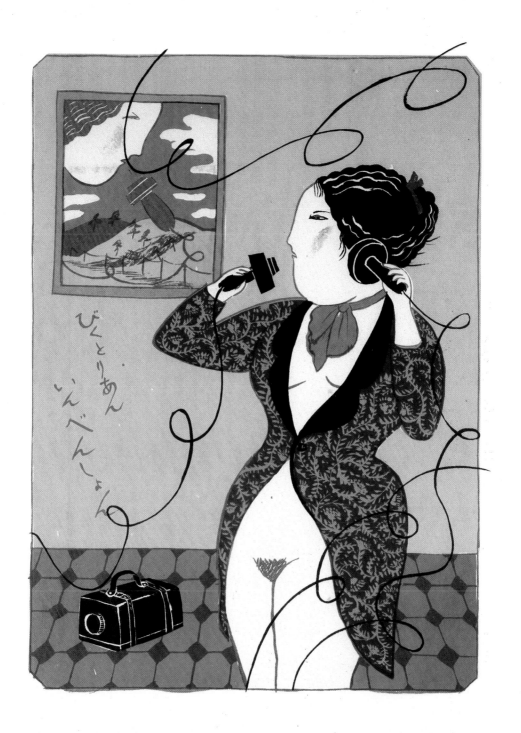

Victorian Invention. The Pedspeed

I love to watch people roller skate. Especially on a sunny Sunday many people are out in Golden Gate park dressed in various clothes, floating through the empty road.
(16'' x 22'') 1977 ed. 50

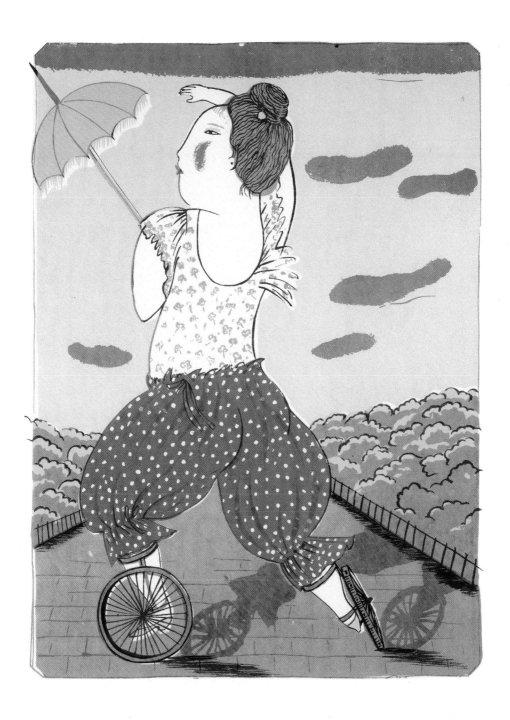

Victorian Invention. An Aerial Cycle

I have a book called *Victorian Invention*, by Leonard De Vries, in which I found a picture of an aerial cycle. Among all the other incredible inventions, some one actually tried to make an aerial cycle, and to our disappointment did not succeed. I feel it is very important to insist on our dreams.

(16'' x 22'') 1977 ed. 50

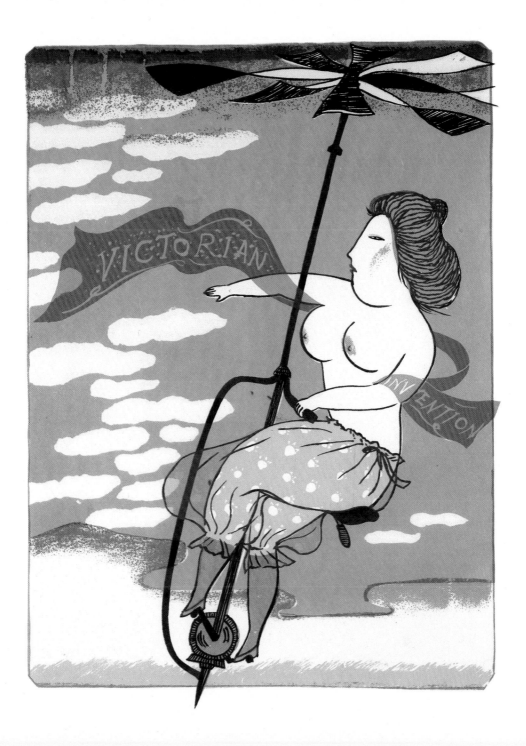

Aphrodite

How do I approach Aphrodite? I give myself golden skin and long black hair and I am Aphrodite herself. I let the Aegean Sea and the South Wind wash me to Cypress. All of us create our own legends.

(23'' x 32'') 1978 ed. 60

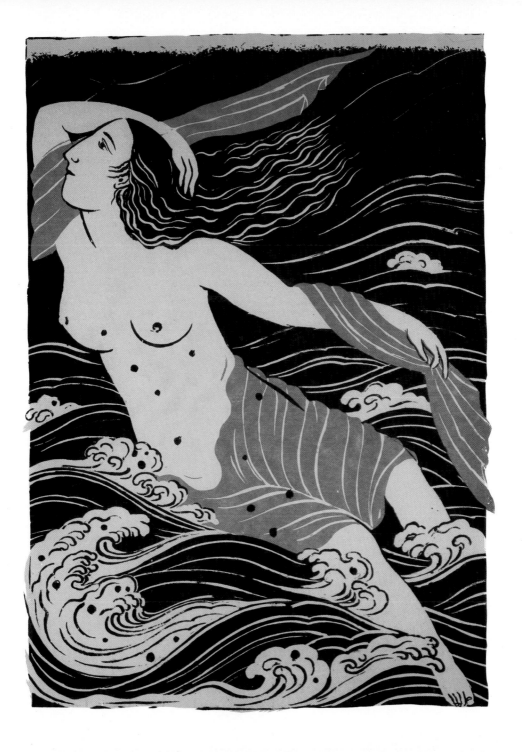

Flower Viewing

Cherry blossoms are the best loved flowers in Japan. I invited a dancer out of a 16th century Japanese screen to join my flower viewing party. I asked her to take her costume off to enjoy the thick full blossoms and falling petals. *(22'' x 29'') 1971 ed. 50*

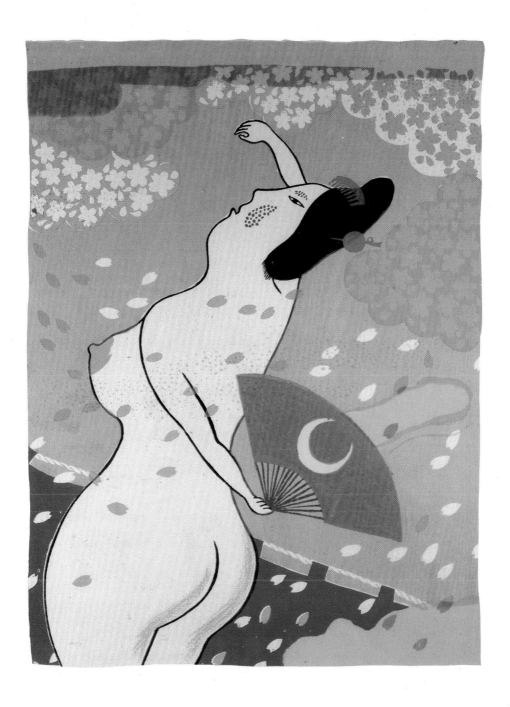

Spring Goddess

When the fire-bombing of Tokyo began, my mother and I fled to the north-country. In the spring, we would go to a hill near a river bank to pick wild plants and eat horse-tails, ferns, and wild chives. I hated the plant stain on my fingers; the strong fragrance of the wild north stayed with me.

(22″ x 29″) 1974 ed. 35

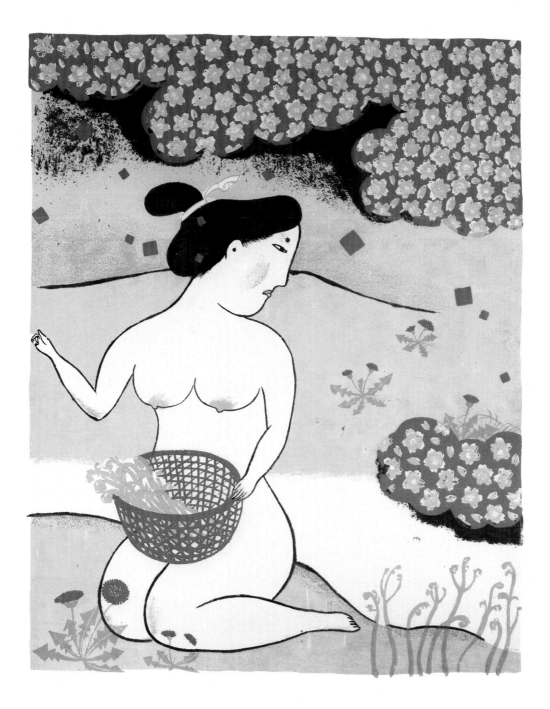

Rain in May

When I was in the first grade I drew a picture of myself singing in the rain with my new umbrella and black rubber rain boots. The picture won first prize in the school Art Show. Then I announced to my family that I would be an artist when I grew up.

(22" x 29") 1975 ed. 35

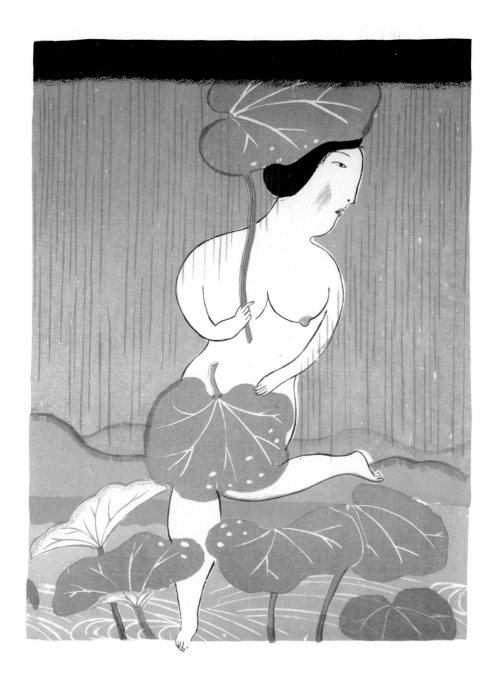

Spring Meadow

The explosion of color and energy in the Spring has always thrilled me. Walking through a flowering field, I feel one with the world. *(22'' x 29'') 1975 ed. 35*

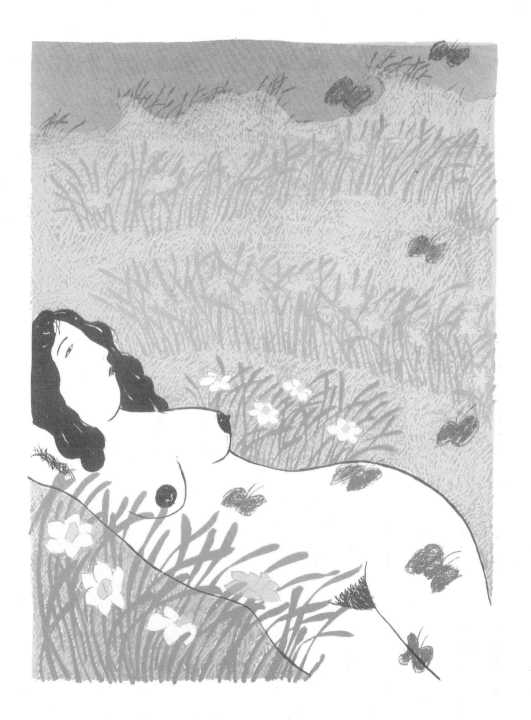

August Moon

Takeojima Island is famous for the shrine of the Benten Goddess (Goddess of art, music and wealth) and the many centuries old well-kept laquer wares. They are usually decorated in deep red and black. They have patterns of rabbits, which are considered to be in the moon, pounding mochi rice cakes, jumping over the ocean waves.

(15'' x 20'') 1977 ed. 30

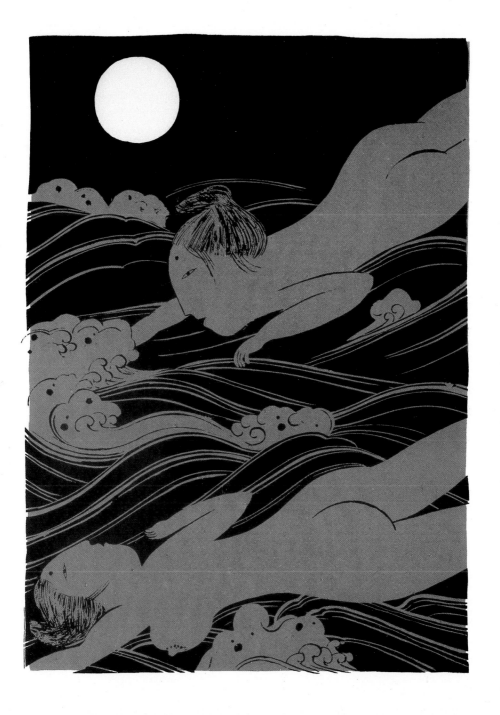

Goddess Coming to You;
Can You Come to Her?

Repeating the name of Kannon Bosatsu (Avalokiteshvara Bodhisattva) hundreds and thousands of times, people eventually get in touch with their own source of energy and compassionate self. This is the simplest, probably the most powerful Buddhist practice. Kannon Bodhisattva is liberating universal energy, and your belief in her makes you a Kannon goddess.

(24" x 33") 1976 ed. 75

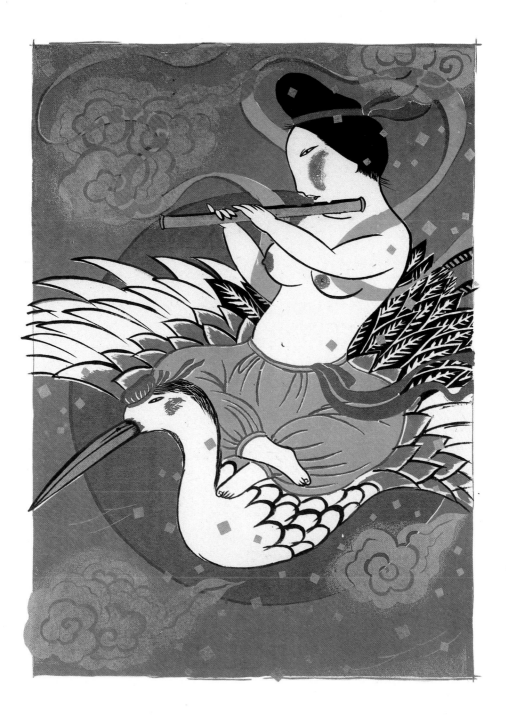

Pearl Diver *(26" x 36") 1977 ed. 50*
When I swim, I am a fish, I am a wave;
I become a sea.

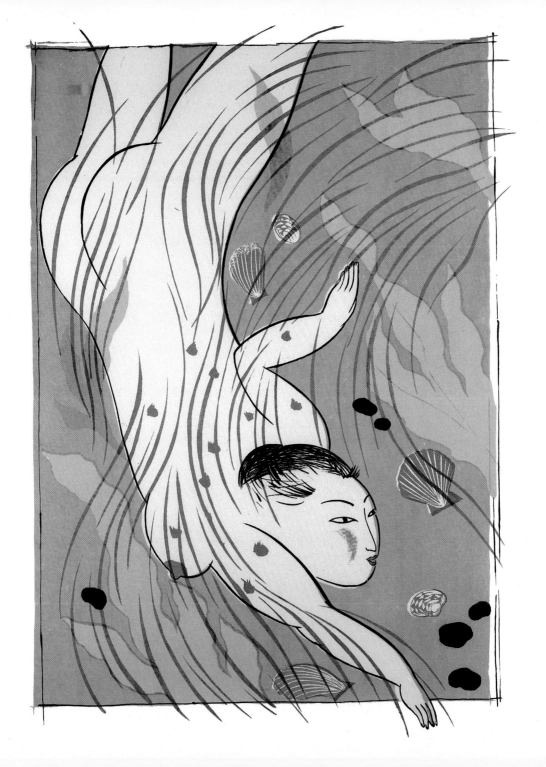

Goddess of Love

Aizen Myōō, *Ragarājā*, is a God of penetrating love, and is always depicted as an angry figure. His anger reminds us of the power to transform desire and passion to compassion. My Goddess of love is the inspiration of love itself. *(25" x 37") 1980 ed. 40*

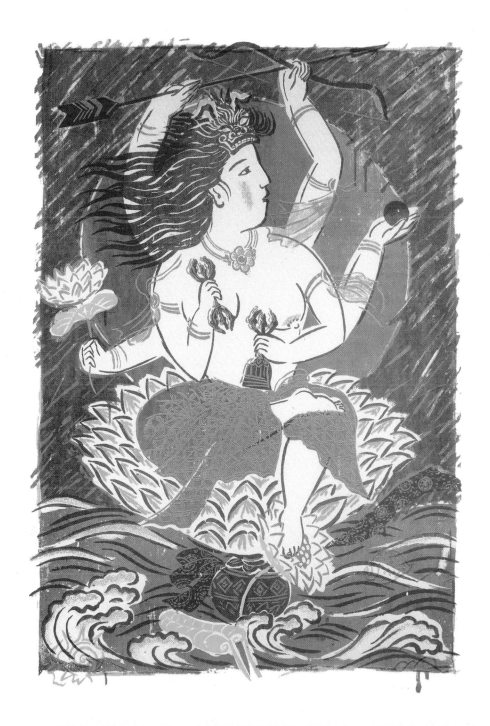

Samantabhadra

Samantabhadra is the shining practice Bodhisattva. Here I would like to express my love and gratitude to all those who encouraged and inspired me over the years.

Yasumasa Oda
John Nathan
Zachary Taro Nathan
Jeremiah Jiro Nathan
Bill Coldwell
Richard Baker
Peter Kaufman

Thank you.

(29" x 40") 1980 ed. 48

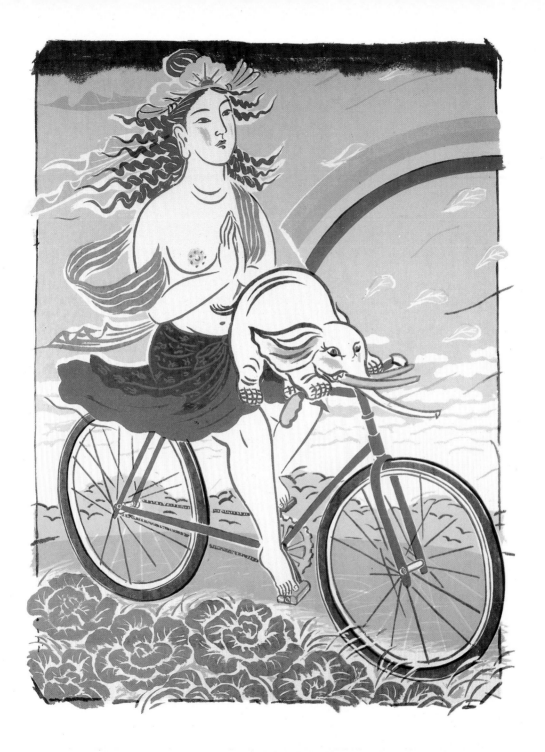

Photograph by Chris Stewart

Mayumi Oda, BIOGRAPHY

1966 Graduated Tokyo University of Fine Arts

1968 Studied Pratt Graphic Center, New York

1969 One-Woman Show, Adams House, Harvard University

1970 Tokyo International Print Biennale

1971 22nd National Exhibition of Prints, Library of Congress

1972 3rd British International Print Biennale,
Bradford City Art Gallery

New Talents in Printmaking, Associated American Artists, New York

One-Woman Show, Yoshii Gallery, Tokyo

1973 One-Woman Show, Art/Asia Gallery, Cambridge

10th International Exhibition of Graphic Art, Ljubljana

1974 Modern Japanese Print Show, Cultural Center, New York

Two-Women Show, Contemporary Asia Art Gallery, Washington, D.C.

1975 24th National Exhibition of Prints, Library of Congress

One-Woman Show, Art/Asia Gallery, Cambridge

One-Woman Show, Mukai Gallery, Tokyo

1976 One-Woman Show, Upstairs Gallery, San Francisco

One-Woman Show, Franell Gallery, Tokyo

Two-Women Show, Ankrum Gallery, Los Angeles

One-Woman Show, Gallery Humanite, Nagoya

1977 2nd World Print Competition, San Francisco

One-Woman Show, Art/Asia Gallery, Cambridge

One-Woman Show, 24 Sather Gate Gallery, Berkeley

1978 One-Woman Show, Mukai Gallery, Tokyo

One-Woman Show, Gallery Humanite, Nagoya

1979 One-Woman Show, Mary Baskett Gallery, Cincinnati

1980 One-Woman Show, Ankrum Gallery, Los Angeles

1981 One-Woman Show, Satori Gallery, San Francisco

One-Woman Show, Tolman Collection, Tokyo

One-Woman Show, Gallery Petit Forms, Osaka

COLLECTIONS

Museum of Modern Art, New York

Museum of Fine Arts, Boston

Cincinnati Art Museum

Library of Congress